ONE TIME
ONE PLACE

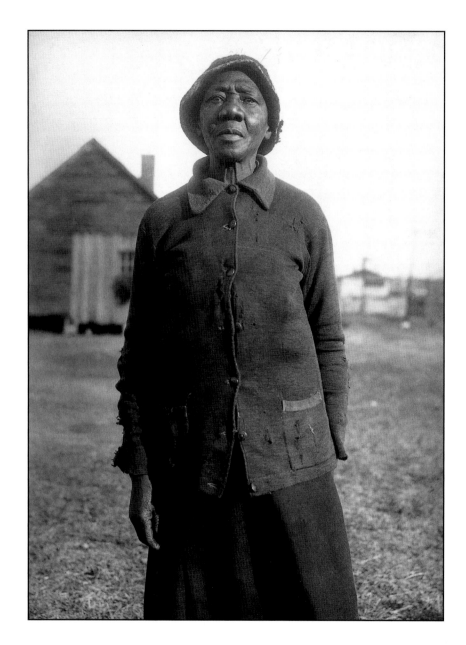

EUDORA WELTY

ONE TIME

ONE PLACE

Mississippi in the Depression

A Snapshot Album

UNIVERSITY PRESS OF MISSISSIPPI JACKSON

All photographs used in this book are from the Eudora Welty Collection,
Mississippi Department of Archives and History.

First published in 1971 by Random House, Inc.
Revised edition copyright © 1996 University Press of Mississippi
Photographs and preface copyright © 1996 by Eudora Welty
Foreword copyright © 1996 by William Maxwell
All rights reserved
Manufactured in the United States of America
Printed in Singapore
Designed by Sally C. Hamlin

99 98 97 96 4 3 2 1

The paper in this book meets the guidelines for permanence and durability of the Committee on Production
Guidelines for Book Longevity of the Council on Library Resources.

Library of Congress Cataloging-in-Publication Data

Welty, Eudora, 1909-
 One time, one place : Mississippi in the Depression : a snapshot album / Eudora Welty.
 p. cm.
 Originally published: New York: Random House, 1971.
 ISBN 0-87805-866-4 (cloth)
 1. Mississippi—Pictorial works. 2. Depression—1929—Mississippi—Pictorial works.
 3. Documentary photography—Mississippi. I. Title.
 F342.W448 1996
 976.2'062'0222—dc20

 95-46057
 CIP

British Library Cataloging-in-Publication data available

TO

CHARLOTTE CAPERS

ACKNOWLEDGMENTS

I wish to express my gratitude to the Mississippi Department of Archives and History, and its director, Dr. R. A. McLemore, for allowing me to reproduce these photographs. I am grateful as well to Mr. James F. Wooldridge, the custodian, for his patience and kindness. And I would like to thank particularly my old friend Miss Charlotte Capers, former director, under whose guidance the Department acquired and is now housing all of my photographs. Her long and affectionate interest in them encouraged me to assemble this book.

BOOKS BY EUDORA WELTY

CONTENTS

PART TWO

SATURDAY

PART THREE

SUNDAY

PART FOUR

PORTRAITS

ONE TIME
ONE PLACE

FOREWORD

In hiring Eudora Welty as a publicity agent, in the mid-1930s, the Works Progress Administration was making a gift of the utmost importance to American letters. It obliged her to go where she would not otherwise have gone and see people and places she might not ever have seen. A writer's material derives nearly always from experience. Because of this job she came to know the state of Mississippi by heart and could never come to the end of what she might want to write about. *One Time, One Place* is a record of her schooling. I am inclined to take exception, however, to her statement that the merit of these photographs lies entirely in the subject matter. Other people could have focused a camera on the same scenes and human situations and they would not have caught what she caught.

Take those three boys standing in front of a side show at the State Fair (page 79). They are never out of each other's company if they can help it. Looking at them I almost know their names. Their ancestors came from the British Isles a long, long time ago. The two bigger boys have learned that not everything claiming to be a wonder is one. The smaller boy sees what he is intended to see. The mermaid. The five-legged calf. They don't know they are being photographed and so this is how they really are. This is how the angels (and the photographer) saw them.

The same thing is true of the two women who are about to cross the street (page 59). In a town where the traffic is negligible, one of them is mortally afraid of being run over. And besides, her feet are killing her.

The preacher and leaders of Holiness Church (page 87) know they are being photographed but it is a matter of indifference to them since they are bent on invoking the presence of the Lord. And have succeeded.

As always in photography, objects compete with persons in interest. Unless I am mistaken, in the picture of the storekeeper on page 108 there is a wall telephone such as I used to see occasionally when I was a child, in the second decade of this century. It was already obsolete then. If you turned the crank you got a human voice, the voice of Central. The voice of the Past.

Looking at the picture on page 110 I am reminded of how, all summer long, my grandmother kept the air around her stirring with a palm-leaf fan. The electric fan and the air conditioner have driven this useful object out of existence in the North and perhaps everywhere except where there is no electricity or no money to pay for it.

Consider the little girl, all in white, on her way to Sunday School (page 85). The apple of somebody's eye. And knows it.

And the boy on page 33. Out of next to nothing—out of somebody's discarded newspaper, pieces of string, and flour-and-water paste he has made what to our eyes is a work of art and to his a kite. Which he asks us to admire. The artist showing his work. The kite is well made. It won't suddenly duck and swerve and come crashing down. It will soar in the sublime upper air.

Admiring the rich black of the shadow under the brim of the yard man's hat (page 113) and the shining black of his face, I didn't at first see that tucked in the brim of his hat are red roses.

Some things require (and deserve) looking at more than others. For example, feet—both bare and shod. Clotheslines. Automobile tires that have seen better days. And nothing is so strange as the commonplace: a house well on the way to rack and ruin, telephone wires, light and shadow, reflections in a store window—Miss Welty's camera caught and did justice to them all.

I do not like to leave home if I can help it but when I consider the courthouse on page 53 I want to get on a plane or train or bus and head for Canton,

4

Mississippi. The ground it covers appears to be hardly bigger than a tennis court but Palladio would have clapped his hands at the sight of it—of the truth of his ideas being once more demonstrated. Grandeur is not a matter of size but is evoked by ideal proportions.

If you grew up in a small town, as I did, what you may see in the picture on page 21, of the tomato packers listening to a man with a guitar, is the good-natured acceptance that comes with over-familiarity.

If there is a judgment anywhere in this book it is in the picture on page 109. The partly-concealed letters arranged vertically on the ribbon across the woman's chest must spell "Matron of Honor." Unencumbered by the slightest information about her, I wonder if the ribbon should read "Socially Prominent."

The girl on page 31 is not waiting for anything; she just is.

The hand is quicker than the eye but only when the eye is distracted. This did not happen with the young woman from Jackson who took these pictures. She was wholly occupied with what was there before her. Sympathy and empathy held her, and arrest the reader on every page, six decades later.

In Eudora Welty's novel *The Optimist's Daughter* there is a sentence that could have stood as an epigraph to this book: "The mystery of how little we know of other people is no greater than the mystery of how much."

To study the pictures in *One Time, One Place* is to gravitate continually between these two mysteries—how little and, after all, how much.

William Maxwell
September 1995

PREFACE

These photographs are my present choices from several hundred I made in Mississippi when I had just come home from college and into the Depression. There were many of us, and of those, I was also among the many who found their first full-time jobs with the Works Progress Administration. As publicity agent, junior grade, for the State office, I was sent about over the eighty-two counties of Mississippi, visiting the newly opened farm-to-market roads or the new airfields hacked out of old cow pastures, interviewing a judge in some new juvenile court, riding along on a Bookmobile route and distributing books into open hands like the treasures they were, helping to put up booths in county fairs, and at night, in some country-town hotel room under a loud electric fan, writing the Projects up for the county weeklies to print if they found the space. In no time, I was taking a camera with me.

In snapping these pictures I was acting completely on my own, though I'm afraid it was on their time; they have nothing to do with the WPA. But the WPA gave me the chance to travel, to see widely and at close hand and really for the first time the nature of the place I'd been born into. And it gave me the blessing of showing me the real State of Mississippi, not the abstract state of the Depression.

The Depression, in fact, was not a noticeable phenomenon in the poorest state in the Union. In New York there had been the faceless breadlines; on Farish Street in my home town of Jackson, the proprietor of the My Blue Heaven Café had written on the glass of the front door with his own finger dipped in window polish:

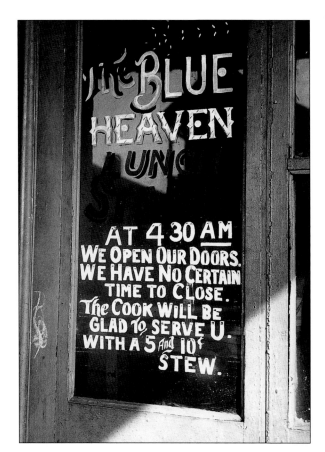

The message was personal and particular. More than what is phenomenal, that strikes home. It happened to me everywhere I went, and I took these pictures.

Mine was a popular Kodak model one step more advanced than the Brownie. (Later on, I promoted myself to something better, but most of the pictures here were made with the first camera.) The local Standard Photo Company of Jackson developed my rolls of film, and I made myself a contact-print frame and printed at night in the kitchen when I was home. With good fortune, I secured an enlarger at second-hand from the State Highway Department, which went on the kitchen table. It had a single shutter-opening, and I timed exposures by a trial-and-error system of countdown.

This is not to apologize for these crudities, because I think what merit the pictures do have has nothing to do with how they were made: their merit lies entirely in their subject matter. I presume to put them into a book now because I feel that taken all together, they cannot help but amount to a record of a kind— a record of fact, putting together some of the elements of one time and one

place. A better and less ignorant photographer would certainly have come up with better pictures, but not these pictures; for he could hardly have been as well positioned as I was, moving through the scene openly and yet invisibly because I was part of it, born into it, taken for granted.

Neither would a social-worker photographer have taken these same pictures. This book is offered, I should explain, not as a social document but as a family album—which is something both less and more, but unadorned. The pictures now seem to me to fall most naturally into the simple and self-evident categories about which I couldn't even at this distance make a mistake—the days of the week: workday; Saturday, for staying home and for excursions too; and Sunday.

The book is like an album as well in that the pictures all are snapshots. It will be evident that the majority of them were snapped without the awareness of the subjects or with only their peripheral awareness. These ought to be the best, but I'm not sure that they are. The snapshots made with people's awareness are, for the most part, just as unposed: I simply asked people if they would mind going on with what they were doing and letting me take a picture. I can't remember ever being met with a demurrer stronger than amusement. (The lady bootlegger, the one in the fedora with the drawn-back icepick, was only pretending to drive me away—it was a joke; she knew I hadn't come to turn her in.)

I asked for and received permission to attend the Holiness Church and take pictures during the service; they seated me on the front row of the congregation and forgot me; once the tambourines were sounded and the singing and dancing began, they wouldn't have noticed the unqualified presence of the Angel Gabriel. My ignorance about interior exposures under weak, naked light bulbs is to blame for the poor results, but I offer them anyway in the hope that a poor picture of Speaking in the Unknown Tongue is better than none at all. The pictures of the Bird Pageant—this was Baptist—were made at the invitation, and under the direction, of its originator, Maude Thompson; I would not have dared to interfere with the poses, and my regret is that I could not, without worse interfering with what was beautiful and original, have taken pictures during the Pageant itself.

Lastly, and for me they come first, I have included some snapshots that resulted in portraits: here the subjects were altogether knowing and they look back at the camera. The only one I knew beforehand was Ida M'Toy, a wonderful eccentric who for all her early and middle years had practiced as a midwife and in old age made a second life for herself as an old-clothes dealer; in the Depression she operated on a staggering scale. She wanted and expected her picture to be taken in the one and only pose that would let the world know that the leading citizens of Jackson had been "born in this hand."

It was with great dignity that many other portrait sitters agreed to be photographed, for the reason, they explained, that this would be the first picture taken of them in their lives. So I was able to give them something back, and though it might be that the picture would be to these poverty-marked men and women and children a sad souvenir, I am almost sure that it wasn't all sad to them, wasn't necessarily sad at all. Whatever you might think of those lives as symbols of a bad time, the human beings who were living them thought a good deal more of them than that. If I took picture after picture out of simple high spirits and the joy of being alive, the way I began, I can add that in my subjects I met often with the same high spirits, the same joy. Trouble, even to the point of disaster, has its pale, and these defiant things of the spirit repeatedly go beyond it, joy the same as courage.

In taking all these pictures, I was attended, I now know, by an angel—a presence of trust. In particular, the photographs of black persons by a white person may not testify soon again to such intimacy. It is trust that dates the pictures now, more than the vanished years. And had I no shame as a white person for what message might lie in my pictures of black persons? No, I was too busy imagining myself into their lives to be open to any generalities. I wished no more to indict anybody, to prove or disprove anything by my pictures, than I would have wished to do harm to the people in them, or have expected any harm from them to come to me.

Perhaps I should openly admit here to an ironic fact. While I was very well positioned for taking these pictures, I was rather oddly equipped for doing it. I

came from a stable, sheltered, relatively happy home that by the time of the Depression and the early death of my father (which happened to us in the same year) had become comfortably enough off by small-town Southern standards and according to our own quiet way of life. (One tragic thing about the poor in Mississippi is how little money it did take here to gain the things that mattered.) I was equipped with a good liberal arts education (in Mississippi, Wisconsin, and New York) for which my parents had sacrificed. I was bright in my studies, and when at the age of twenty-one I returned home from the Columbia Graduate School of Business—prepared, I thought, to earn my living—of the ways of life in the world I knew absolutely nothing at all. I didn't even know this. My complete innocence was the last thing I would have suspected of myself. Anyway, I was fit to be amazed.

The camera I focused in front of me may have been a shy person's protection, in which I see no harm. It was an eye, though—not quite mine, but a quicker and an unblinking one—and it couldn't see pain where it looked, or give any, though neither could it catch effervescence, color, transcience, kindness, or what was not there. It was what I used, at any rate, and like any tool, it used me.

It was after I got home, had made my prints in the kitchen and dried them overnight and looked at them in the morning by myself, that I began to see objectively what I had there.

When a heroic face like that of the woman in the buttoned sweater—who I think must come first in this book—looks back at me from her picture, what I respond to now, just as I did the first time, is not the Depression, not the Black, not the South, not even the perennially sorry state of the whole world, but the story of her life in her face. And though I did not take these pictures to prove anything, I think they most assuredly do show something—which is to make a far better claim for them. Her face to me is full of meaning more truthful and more terrible and, I think, more noble than any generalization about people could have prepared me for or could describe for me now. I learned from my own pictures, one by one, and had to; for I think we are the breakers of our own hearts.

I learned quickly enough when to click the shutter, but what I was becoming aware of more slowly was a story-writer's truth: the thing to wait on, to reach there in time for, is the moment in which people reveal themselves. You have to be ready, in yourself; you have to know the moment when you see it. The human face and the human body are eloquent in themselves, and stubborn and wayward, and a snapshot is a moment's glimpse (as a story may be a long look, a growing contemplation) into what never stops moving, never ceases to express for itself something of our common feeling. Every feeling waits upon its gesture. Then when it does come, how unpredictable it turns out to be, after all.

We come to terms as well as we can with our lifelong exposure to the world, and we use whatever devices we may need to survive. But eventually, of course, our knowledge depends upon the living relationship between what we see going on and ourselves. If exposure is essential, still more so is the reflection. Insight doesn't happen often on the click of the moment, like a lucky snapshot, but comes in its own time and more slowly and from nowhere but within. The sharpest recognition is surely that which is charged with sympathy as well as with shock—it is a form of human vision. And that is of course a gift. We struggle through any pain or darkness in nothing but the hope that we may receive it, and through any term of work in the prayer to keep it.

In my own case, a fuller awareness of what I needed to find out about people and their lives had to be sought for through another way, through writing stories. But away off one day up in Tishomingo County, I knew this, anyway: that my wish, indeed my continuing passion, would be not to point the finger in judgment but to part a curtain, that invisible shadow that falls between people, the veil of indifference to each other's presence, each other's wonder, each other's human plight.

Jackson, March 1971

PART ONE

WORKDAY

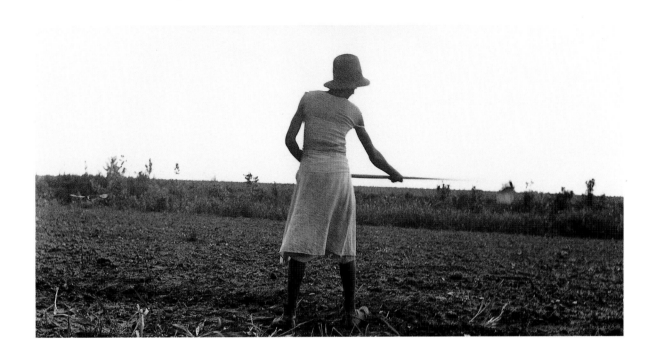

Chopping in the field/WARREN COUNTY

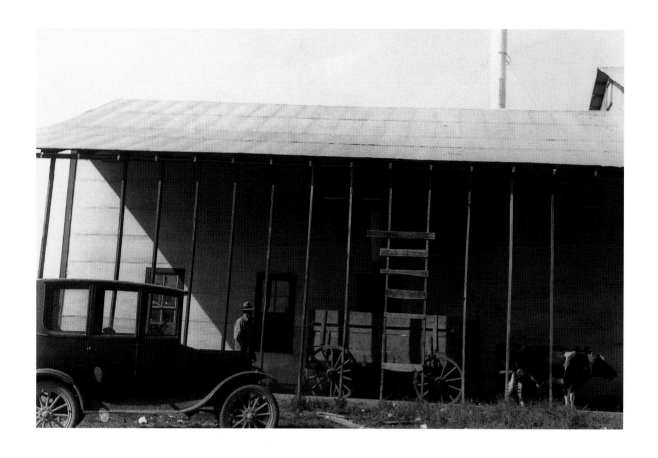

Cotton gin/HINDS COUNTY

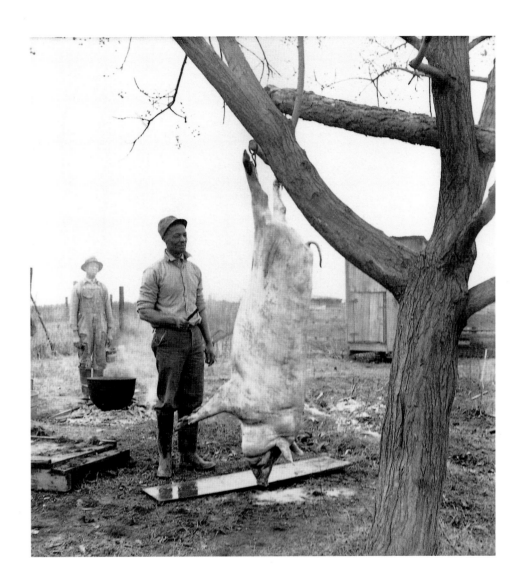

Hog-killing time/HINDS COUNTY

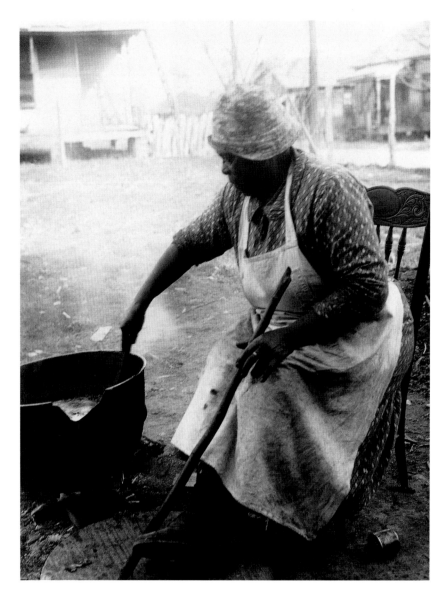

*Boiling pot/*HINDS COUNTY

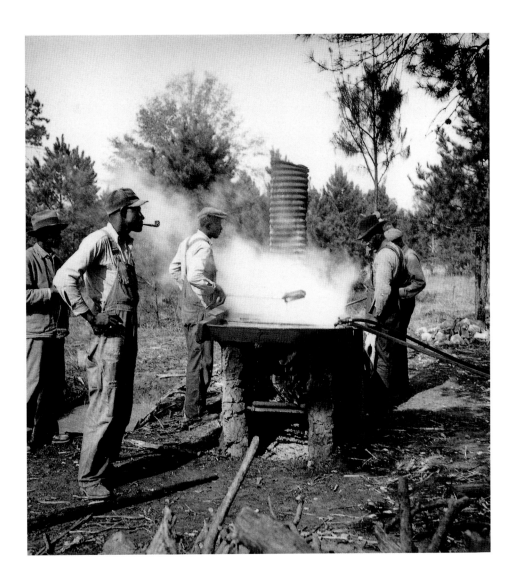

Making cane syrup/MADISON COUNTY

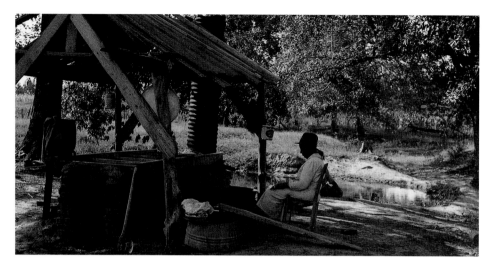

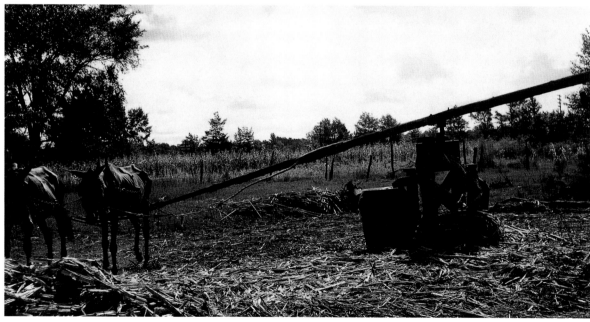

Making cane syrup/MADISON COUNTY

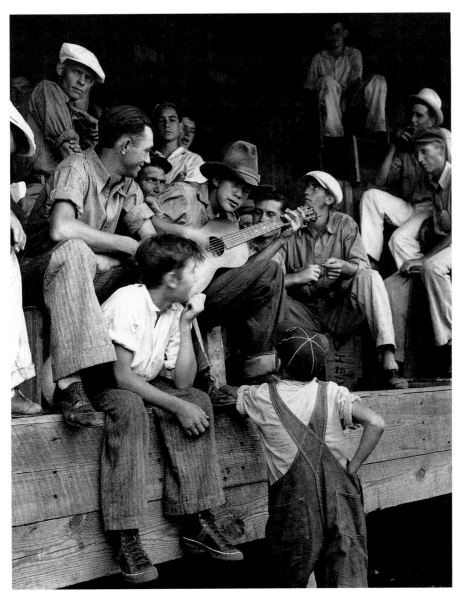

Tomato-packers' recess/COPIAH COUNTY

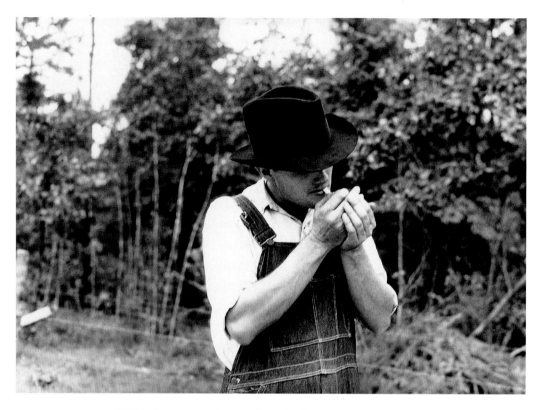

WPA farm-to-market road worker/LOWNDES COUNTY

Washwoman/JACKSON
Washwomen carrying the clothes/YALOBUSHA COUNTY

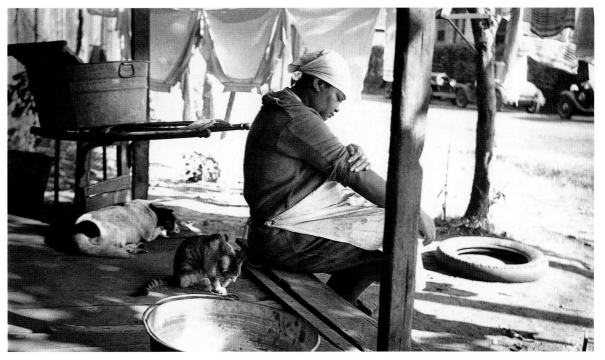

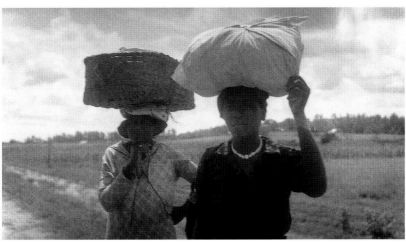

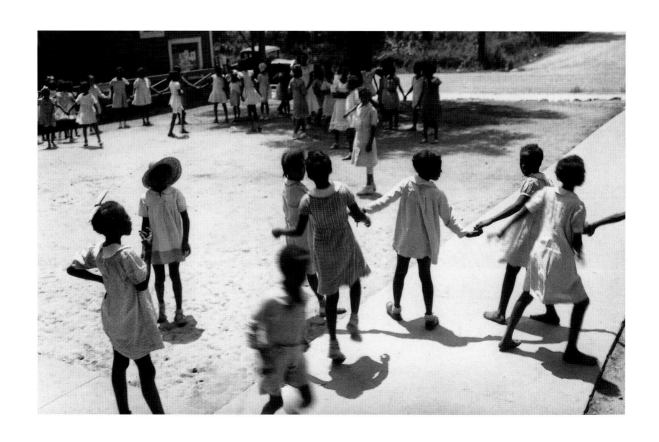

Schoolchildren/JACKSON

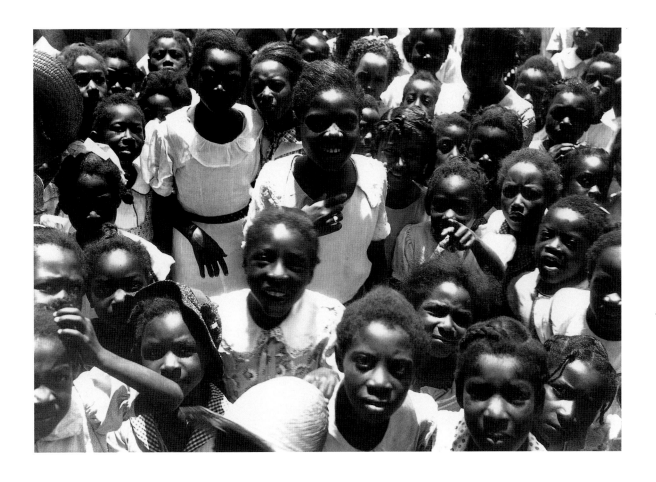

Schoolchildren meeting a visitor/JACKSON

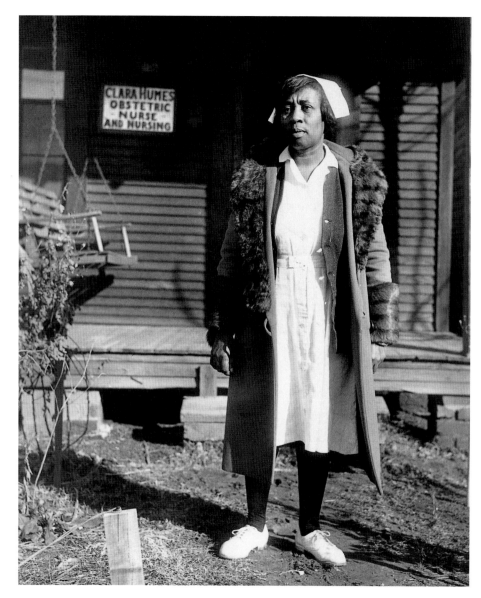

Nurse at home/HINDS COUNTY

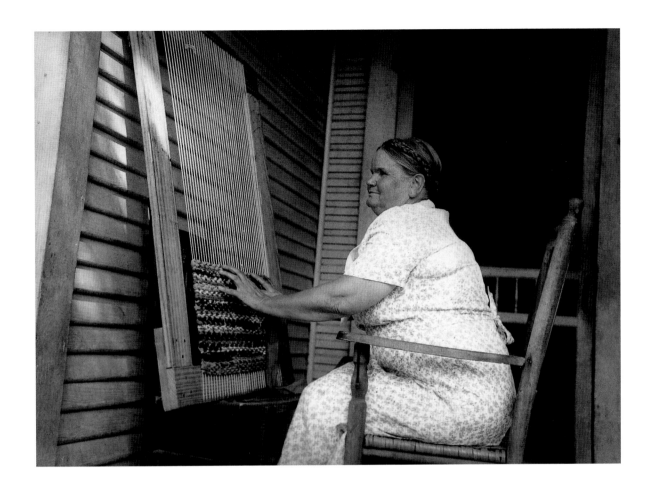

Blind weaver on the WPA

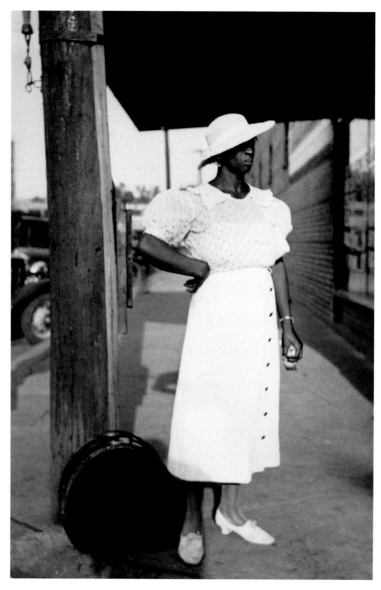

Schoolteacher on Friday afternoon/HINDS COUNTY

PART TWO

SATURDAY

Saturday Off/JACKSON

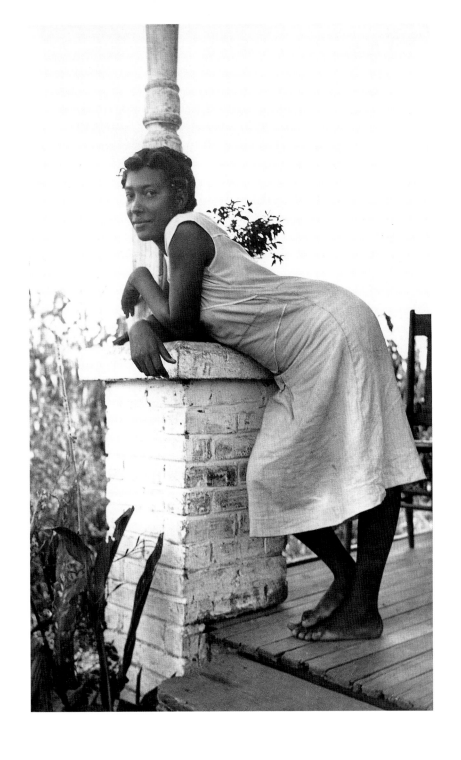

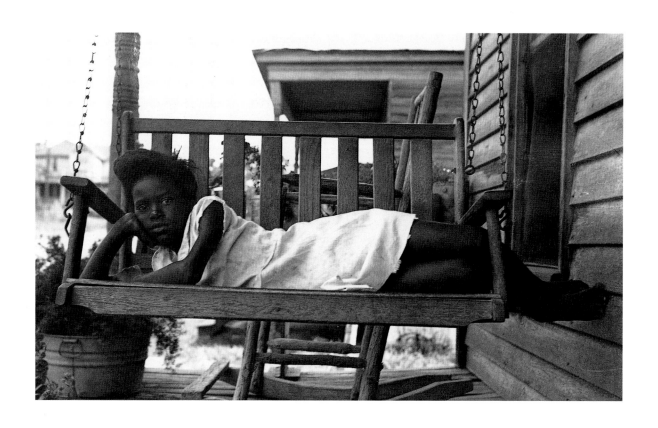

Staying Home/JACKSON

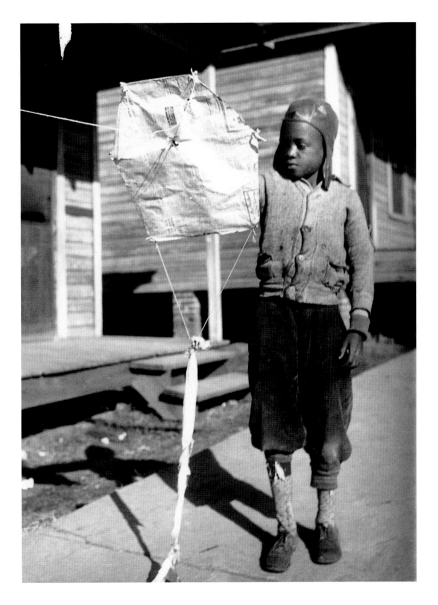

Boy with his kite/JACKSON

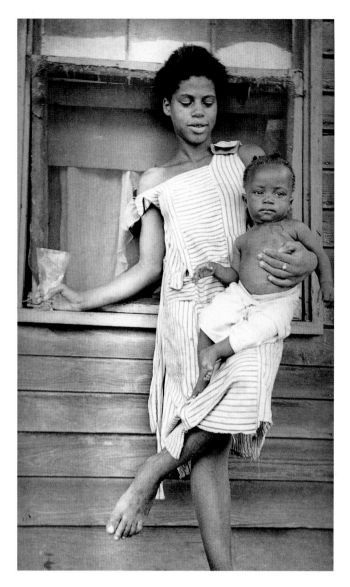

Coke/JACKSON

Hairdressing queue/HINDS COUNTY

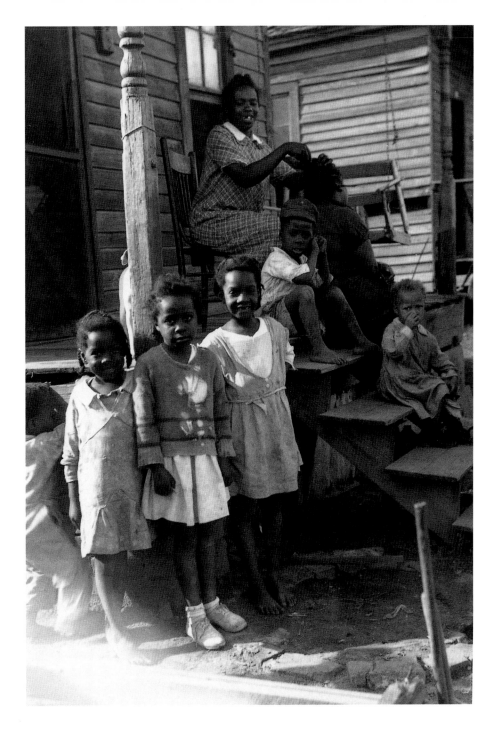

Front yard/YAZOO COUNTY

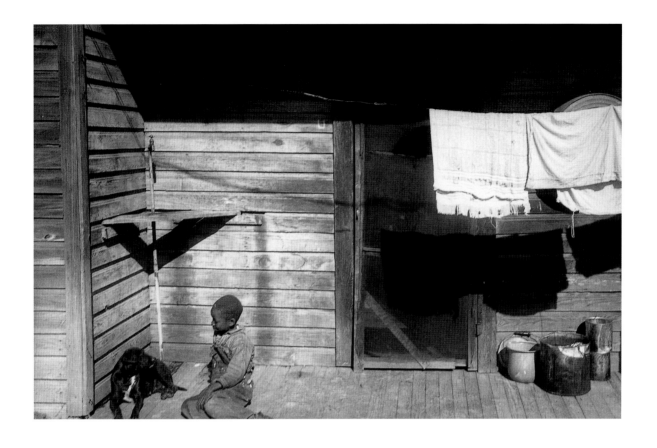

With a dog/UTICA

37

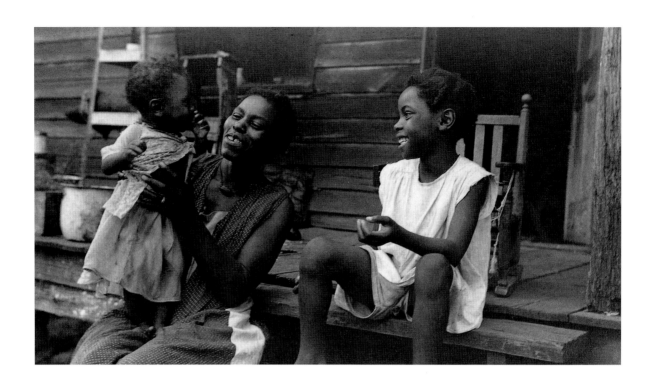

With the baby/HINDS COUNTY

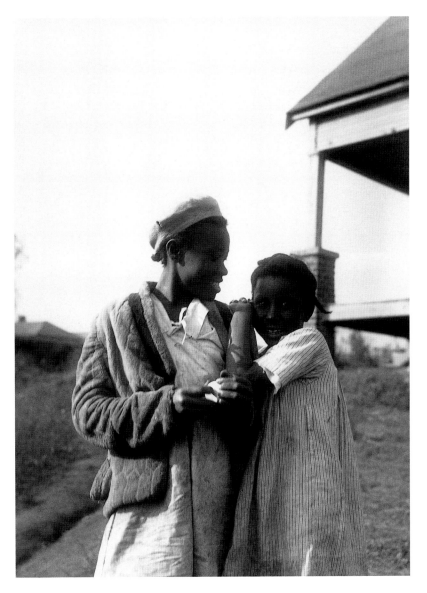

With a chum/MADISON COUNTY

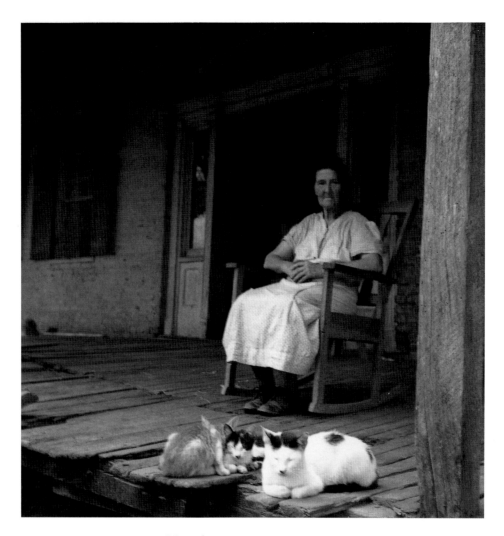

Home/CLAIBORNE COUNTY

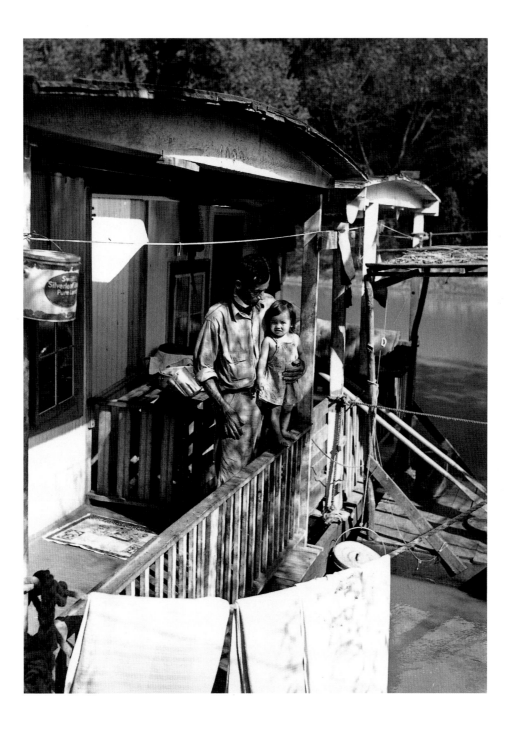

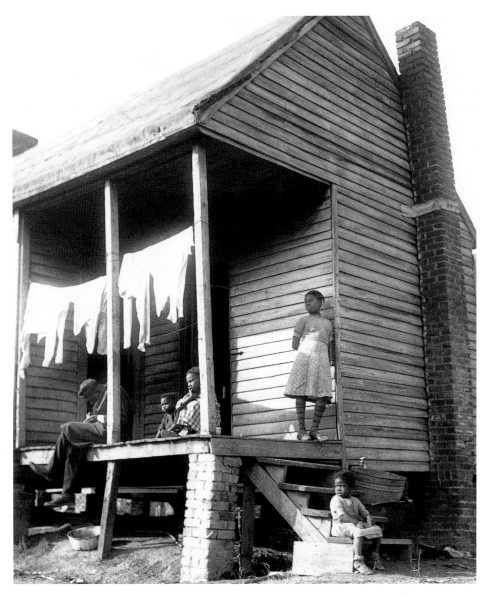

Home/JACKSON

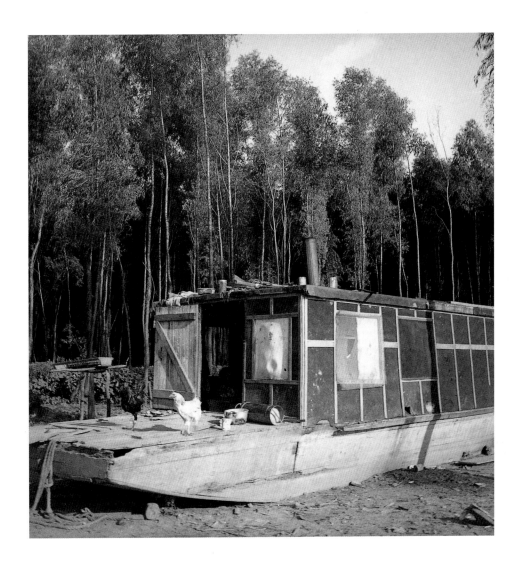

Home/MISSISSIPPI RIVER, NEAR GRAND GULF 43

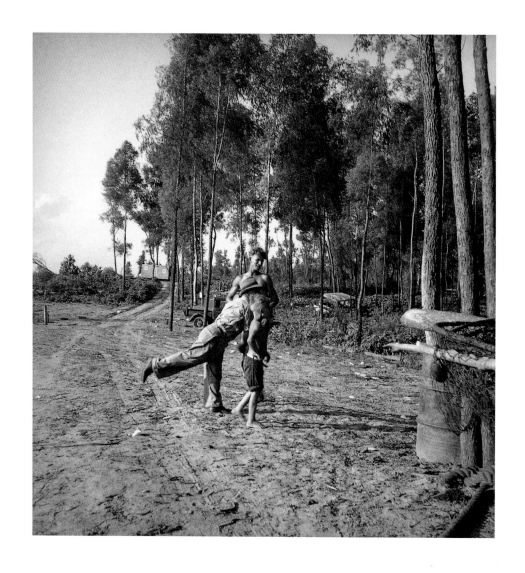

44 *Fisherman and his boys throwing knives at a target*/NEAR GRAND GULF

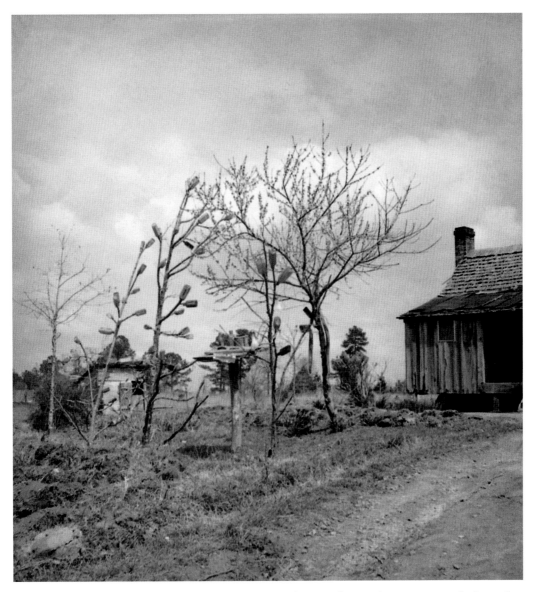

Home with bottle-trees, sometimes said to trap evil spirits that might try to get in the house/
SIMPSON COUNTY

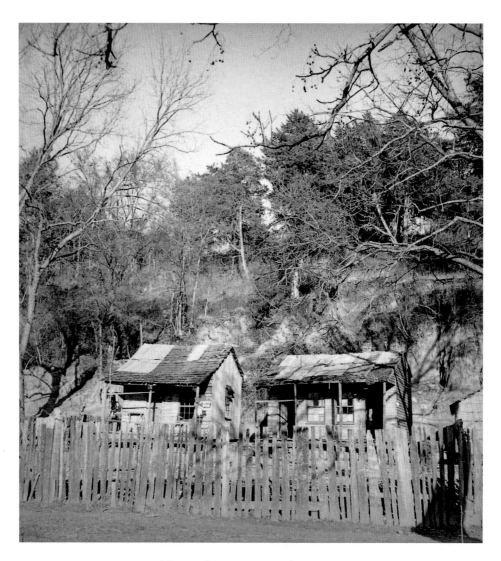

Home, ghost river town/RODNEY

Home after high water/RODNEY

*Home open to the public/*DUNLEITH, NATCHEZ; THE FIRST GARDEN PILGRIMAGE

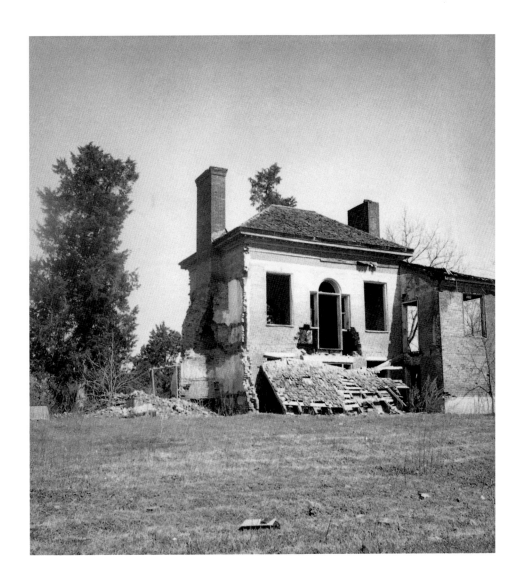

Home abandoned/OLD NATCHEZ TRACE, NEAR CLINTON

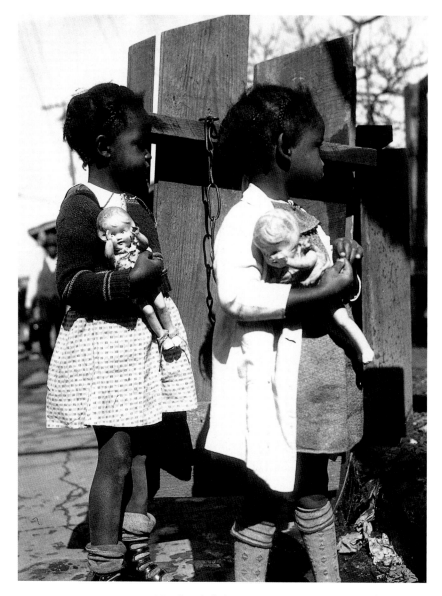

To play dolls/JACKSON

To find plums/COPIAH COUNTY

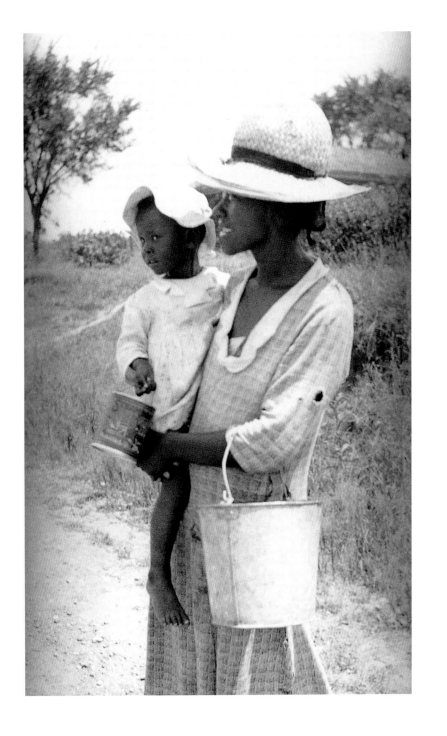

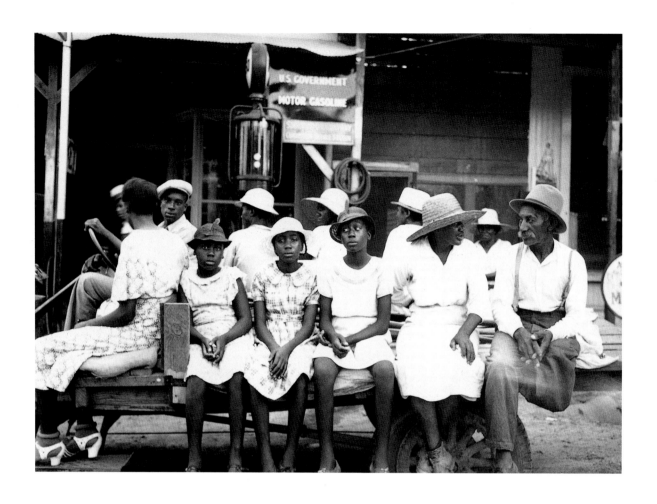

To all go to town/HINDS COUNTY

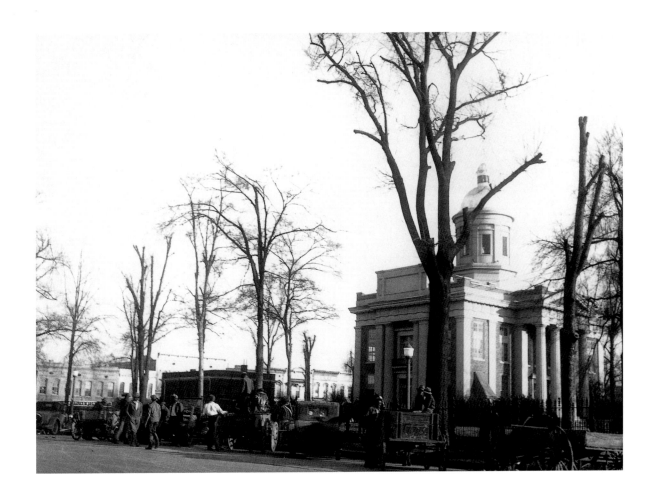

Saturday arrivals/CANTON

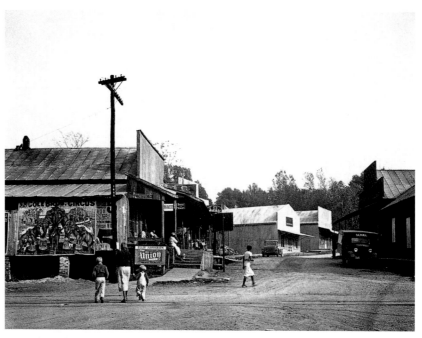

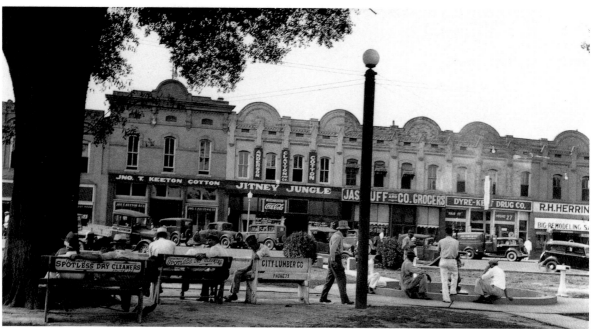

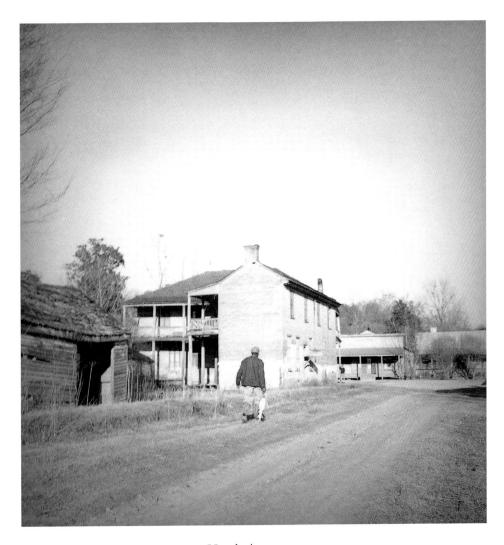

Hamlet/RODNEY

Village/HERMANVILLE

Saturday in town/GRENADA

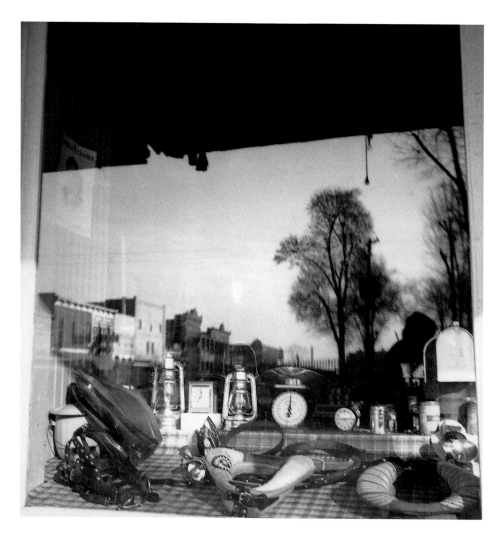

Town in a store window/CANTON

The store/CANTON

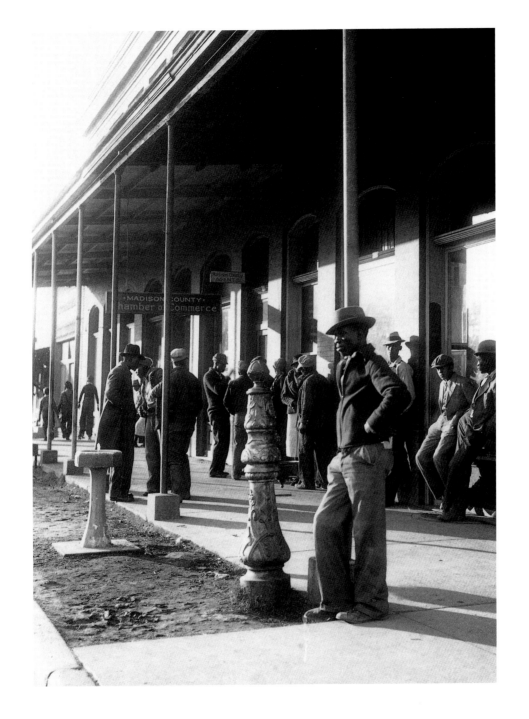

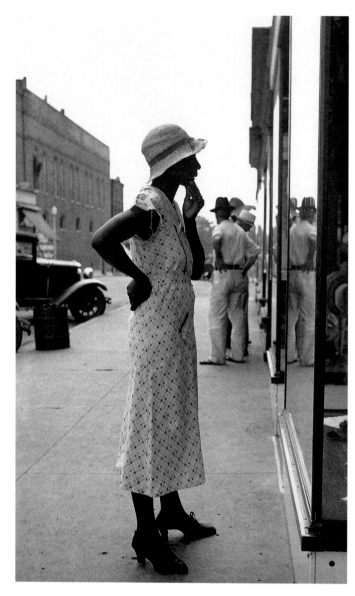

Window shopping/GRENADA

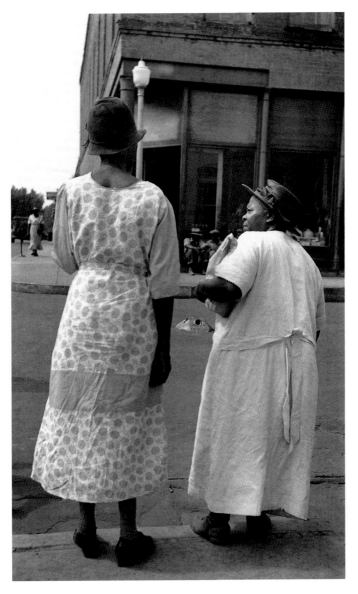

Crossing the pavement/UTICA

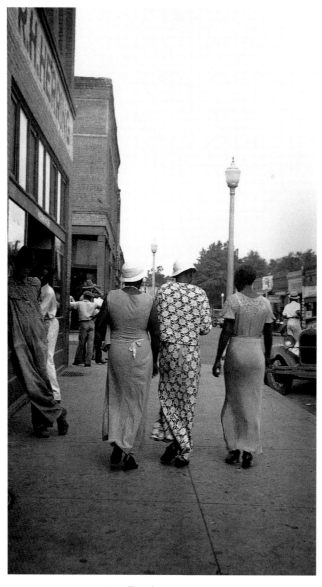

Strollers/GRENADA

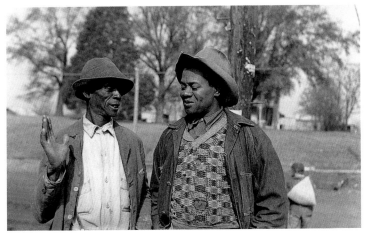

*Tall story/*UTICA

*Farmers in town/*CRYSTAL SPRINGS 61

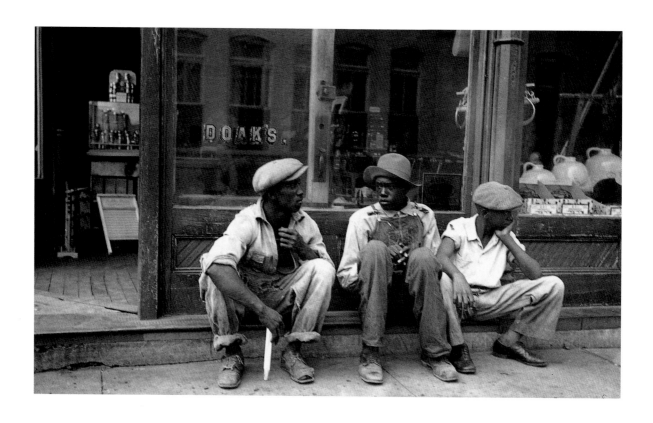

*Store front/*UTICA

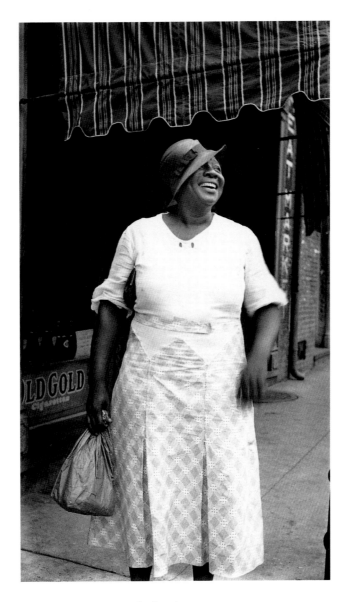

In the bag/CANTON

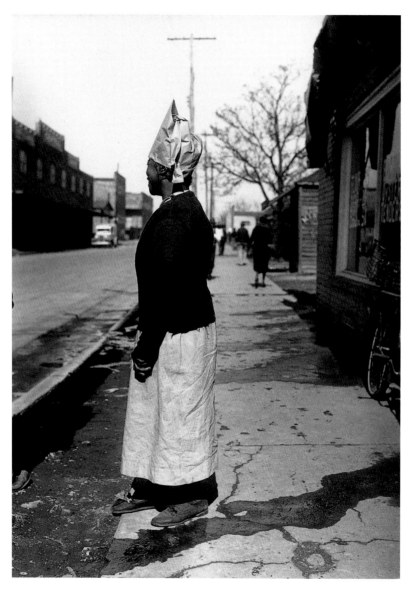

If it rains/JACKSON

Confederate veterans meeting in the park/JACKSON

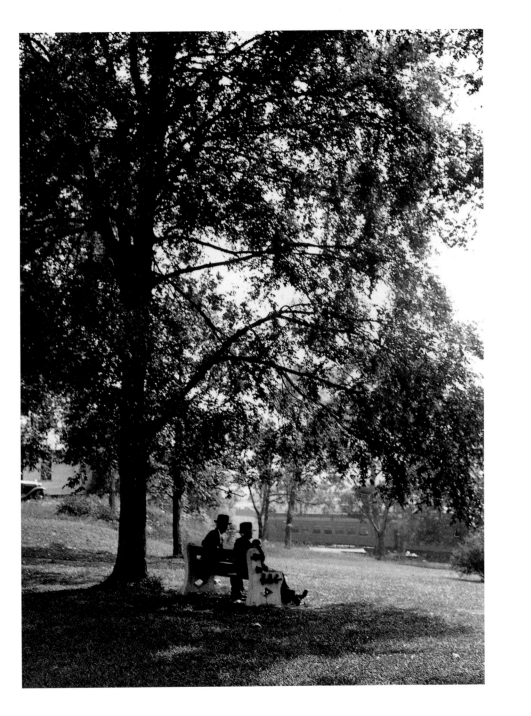

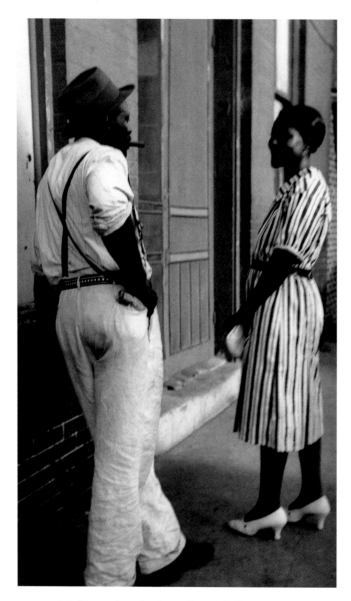

Making a date for Saturday night/JACKSON

Making a date/GRENADA

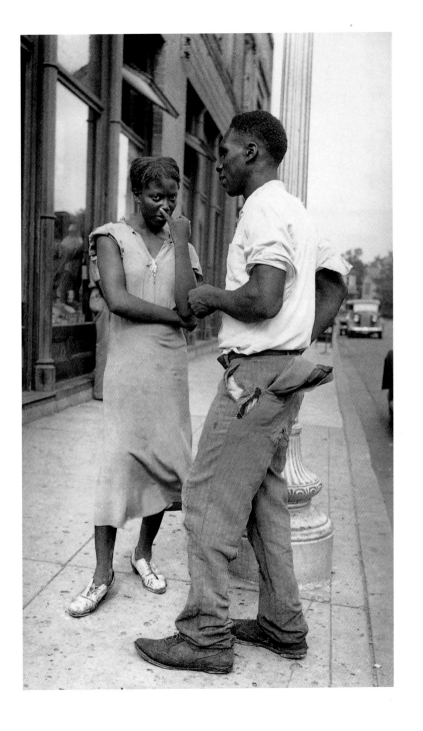

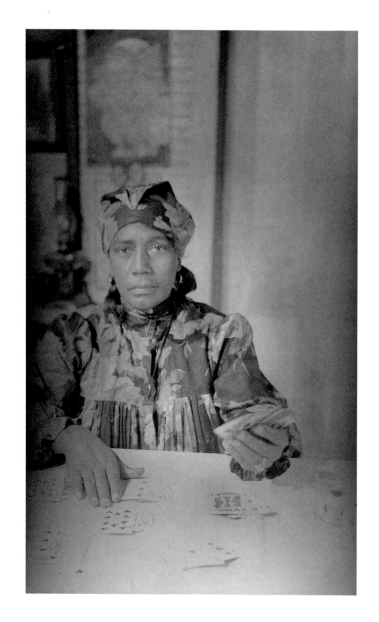

*The fortune-teller's house/*JACKSON

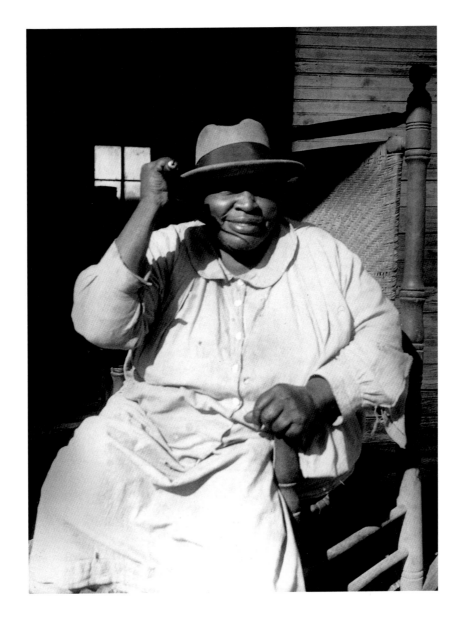

The bootlegger's house. Pretending to drive away customers with an icepick/

HINDS COUNTY

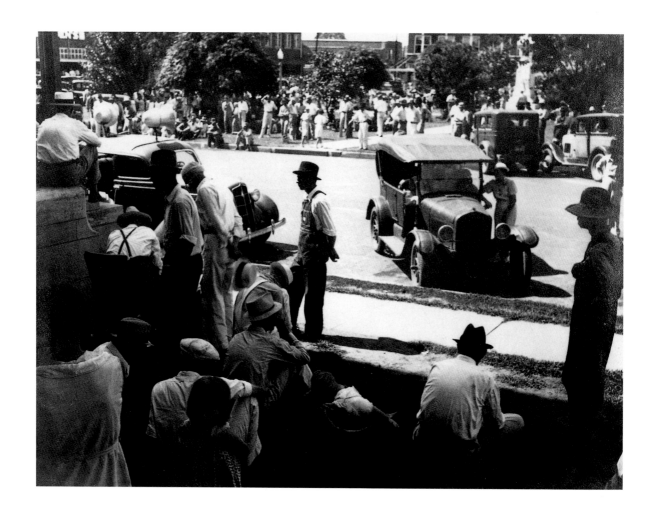

Political speaking/PONTOTOC

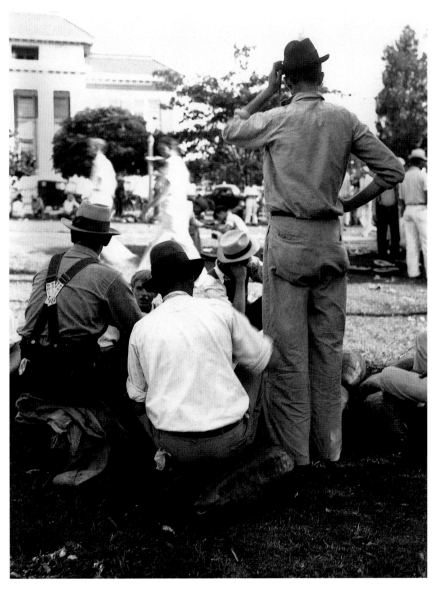

Political speech/PONTOTOC

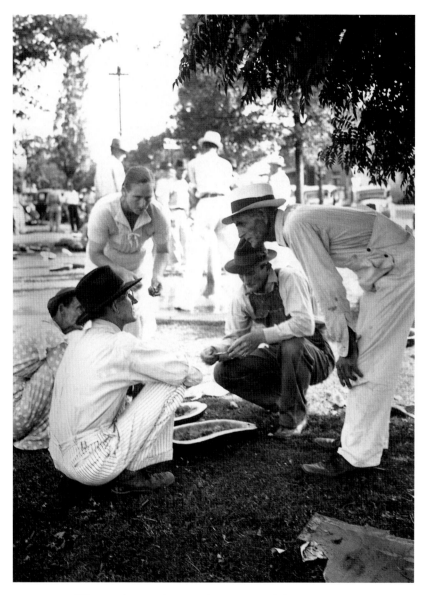

*Watermelon on the courthouse grounds/*PONTOTOC

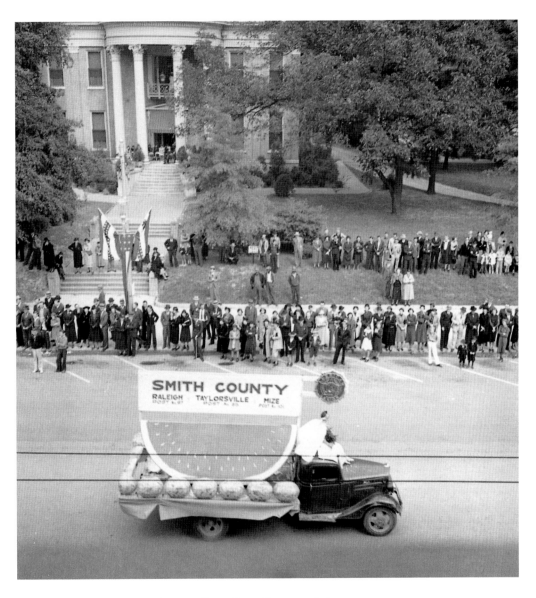

*County float, State Fair parade/*JACKSON

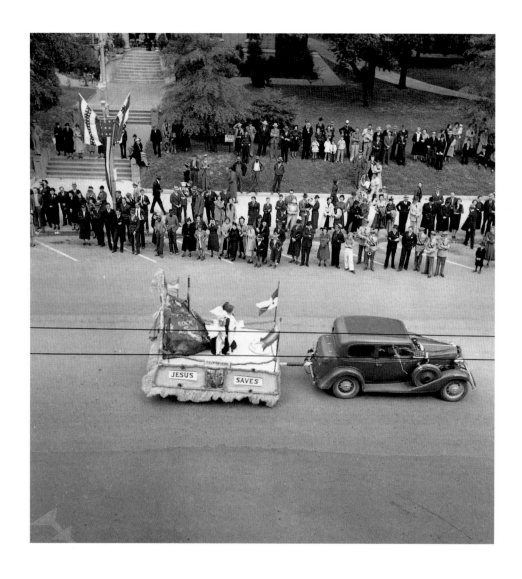

Church float, State Fair parade/JACKSON

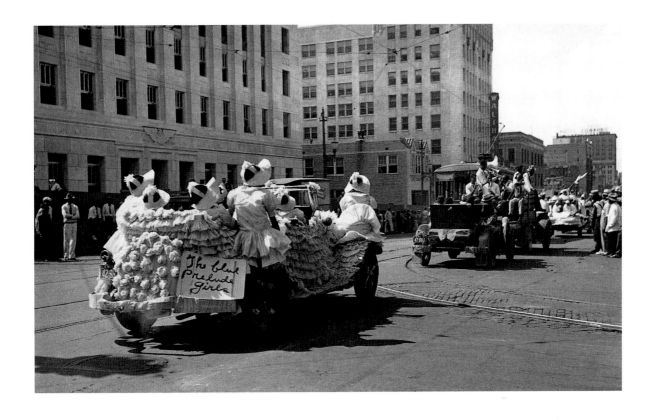

*Club float, Negro State Fair parade/*JACKSON 75

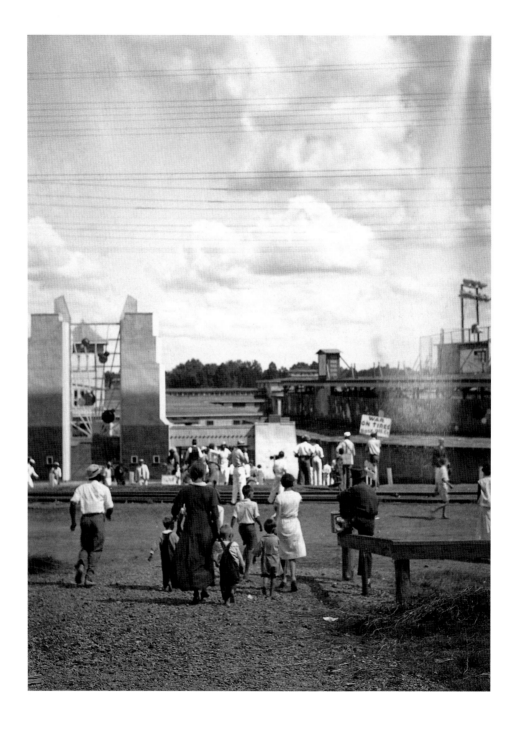

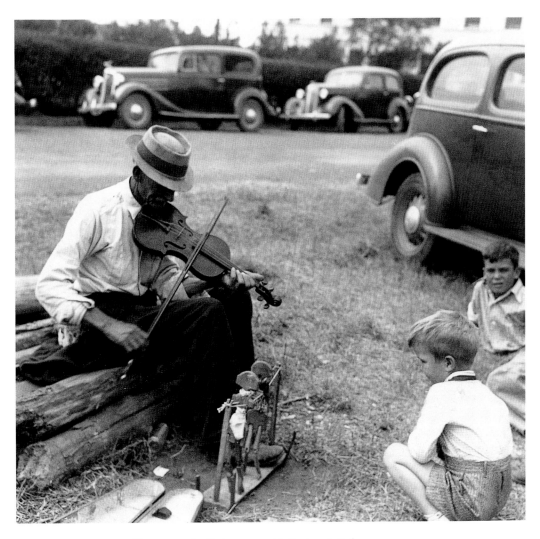

Beggar at the Fair gate, with jigging dolls/JACKSON

Free Gate, State Fair/JACKSON

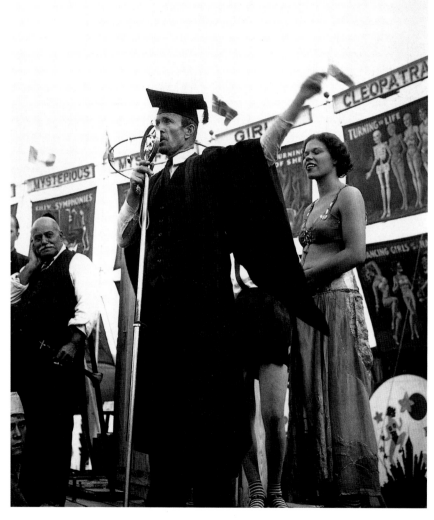

Sideshow, State Fair/JACKSON

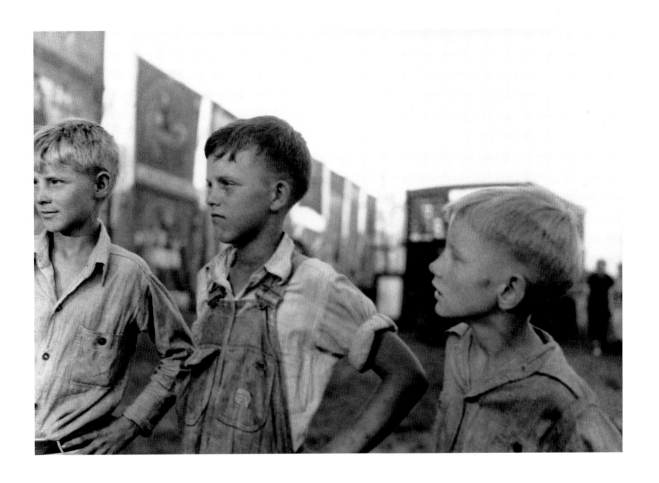

Hypnotist, State Fair/JACKSON

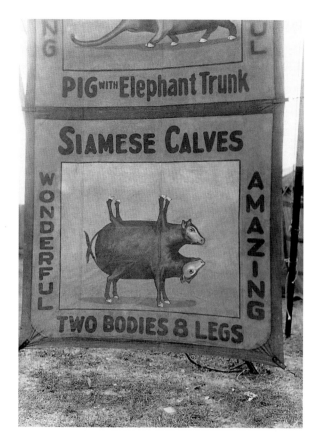

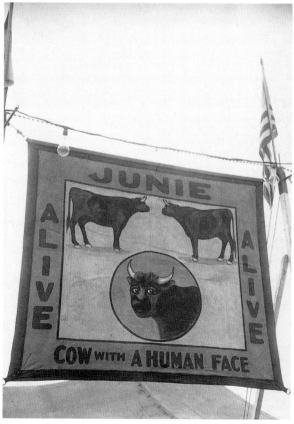

Sideshow wonders, State Fair/JACKSON

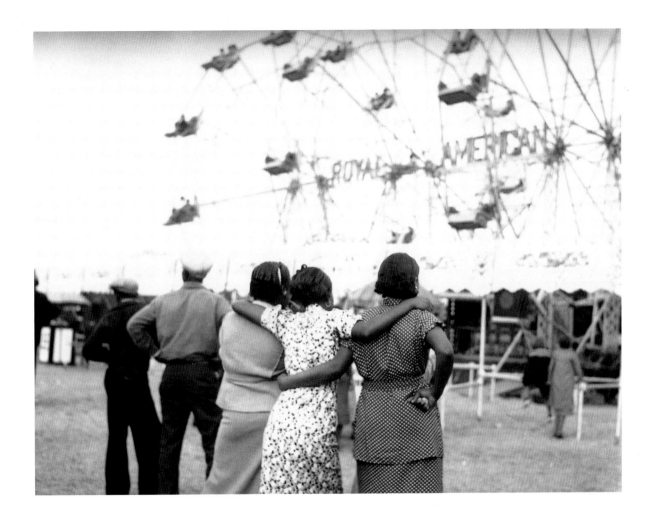

The Rides, State Fair/JACKSON

81

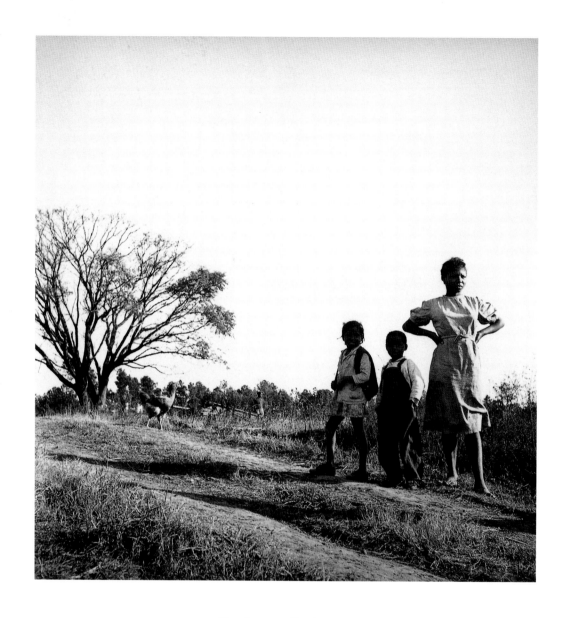

Too far to walk it/STAR

PART THREE

SUNDAY

Sunday School child/JACKSON

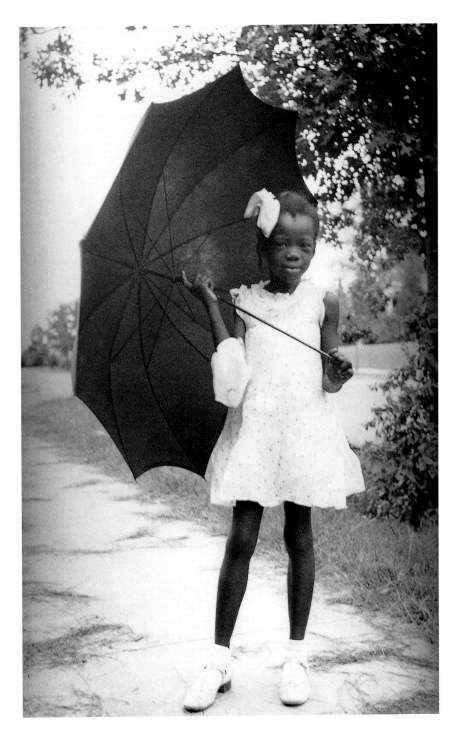

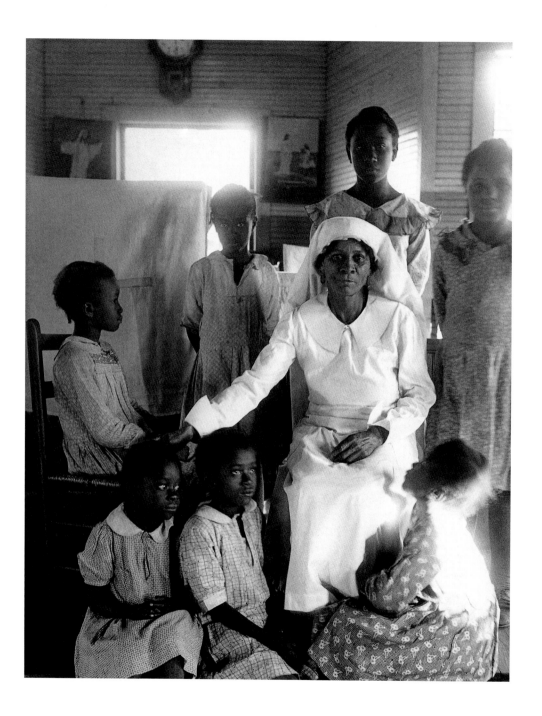

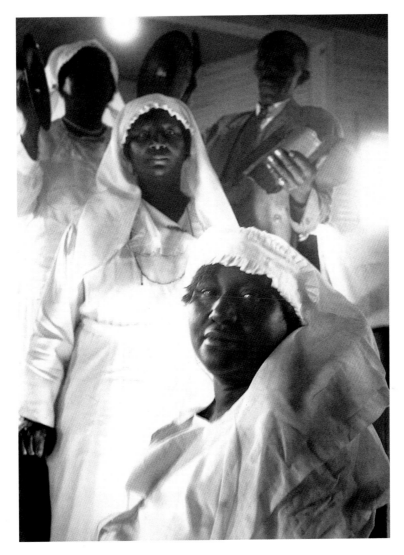

*Preacher and leaders of Holiness Church/*JACKSON

*Sunday School. Holiness Church/*JACKSON

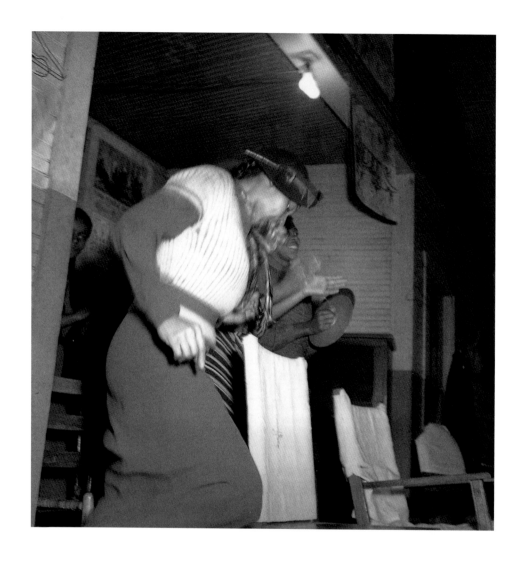

*Make a joyful noise unto the Lord. Holiness Church/*JACKSON

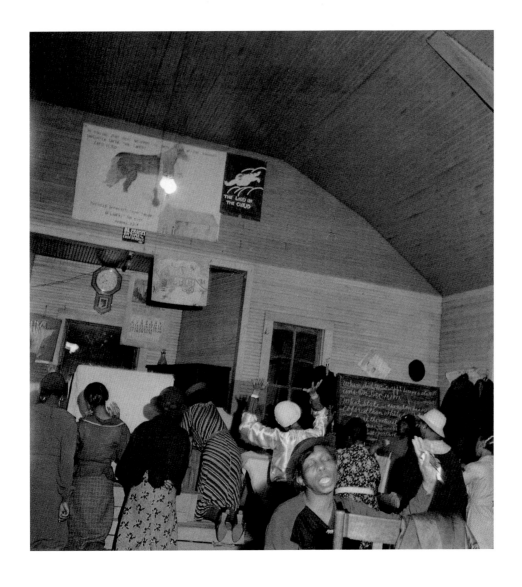

Speaking in the Unknown Tongue. Holiness Church/JACKSON

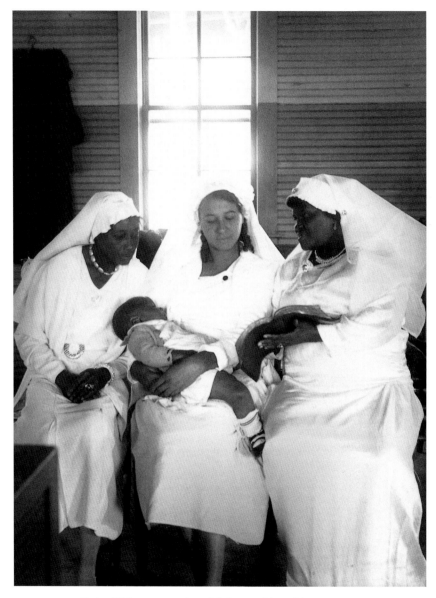

*Baby Holiness member. Holiness Church/*JACKSON

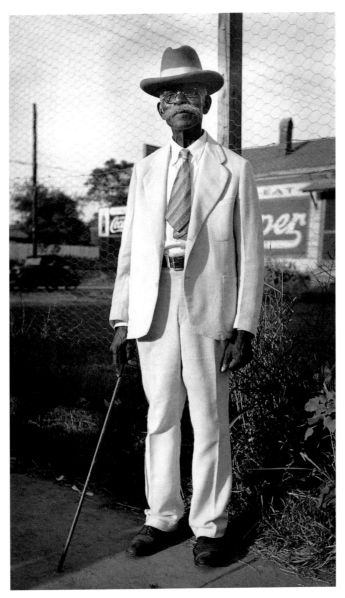

Baptist deacon/JACKSON

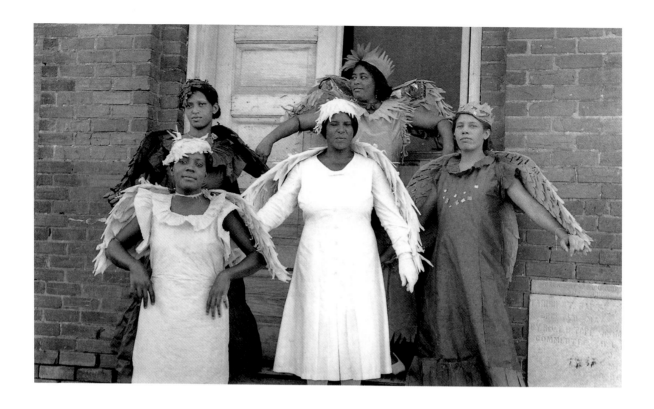

*Members of a Pageant of Birds. Farish Street Baptist Church/*JACKSON

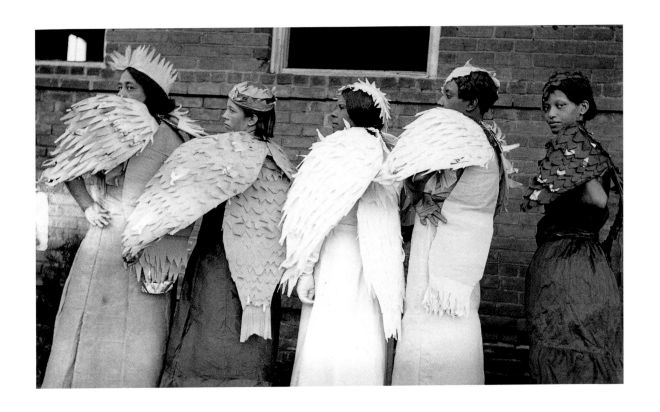

Bird Pageant costumes/JACKSON

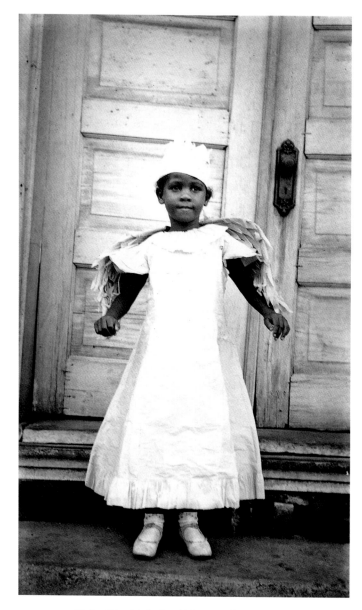

Baby Bluebird, Bird Pageant/JACKSON

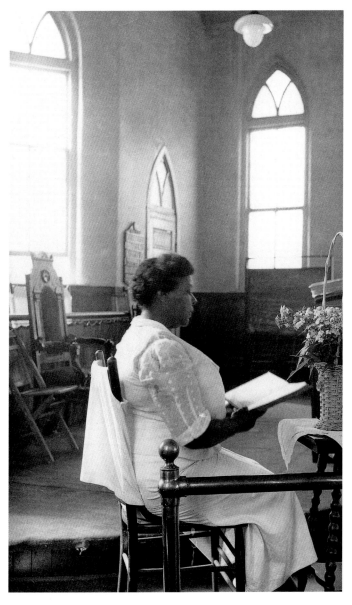

Author and director of the Bird Pageant. "To raise money to buy not a new piano but a better one."/JACKSON

Country church/NEAR OLD WASHINGTON

Country church/NEAR ROCKY SPRINGS

97

Country church/NEAR RODNEY

Church in Port Gibson

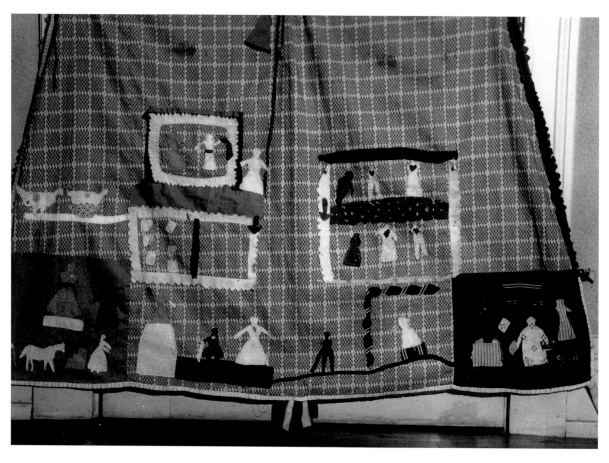

A slave's apron showing souls in progress to Heaven or Hell/YALOBUSHA COUNTY

Carrying the ice for Sunday dinner/NEAR BOLTON

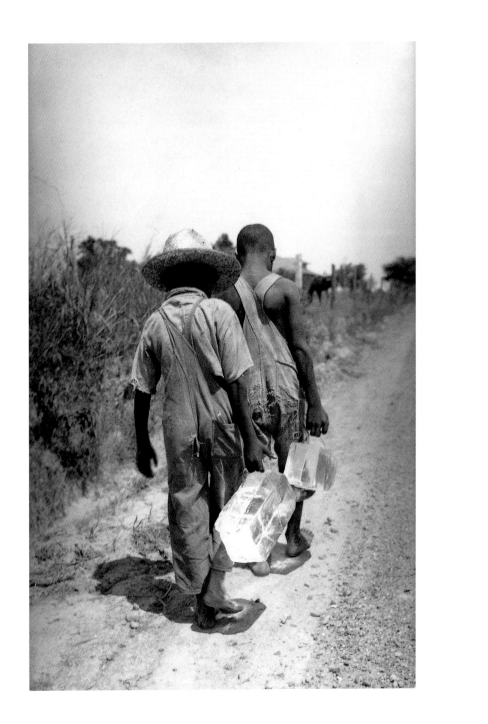

PORTRAITS

Wild flowers/HINDS COUNTY

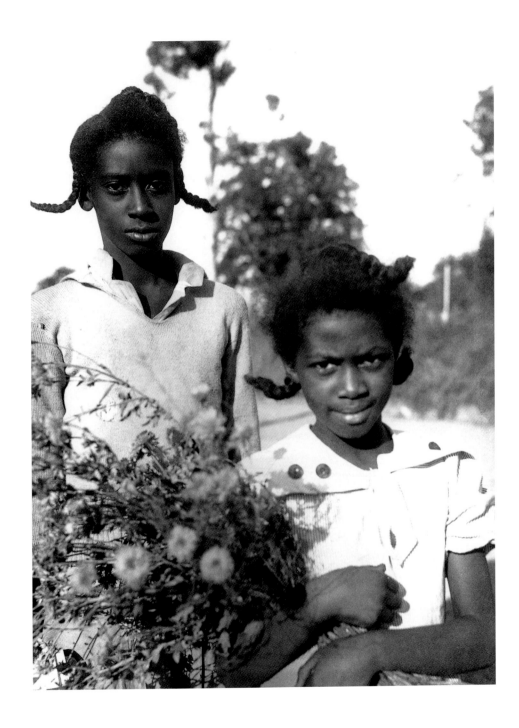

*Ida M'Toy, retired midwife/*JACKSON

Ida M'Toy

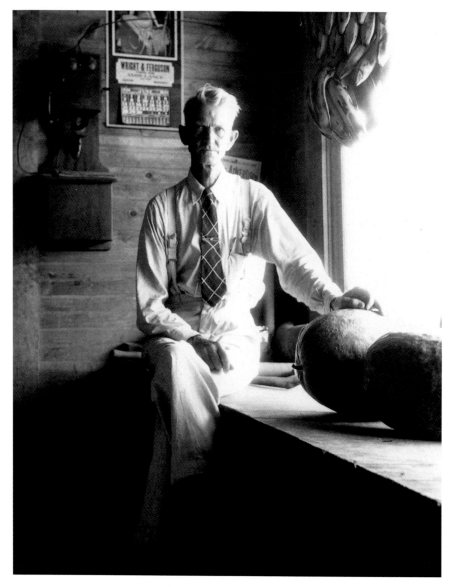

Storekeeper/RANKIN COUNTY

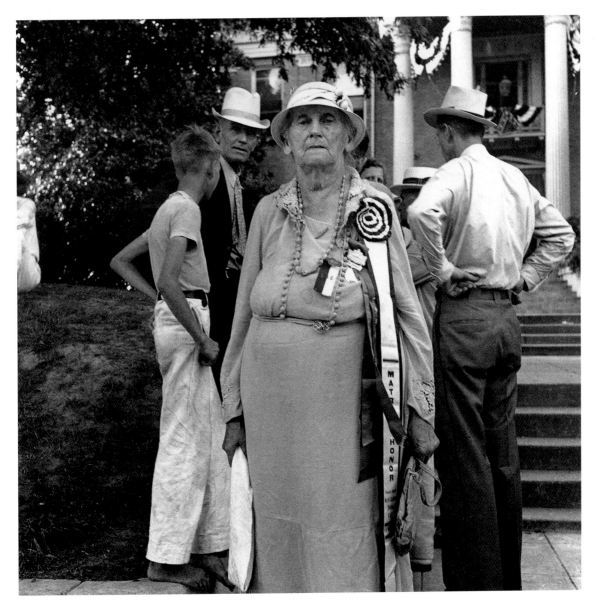

Delegate, Governor's Mansion/JACKSON

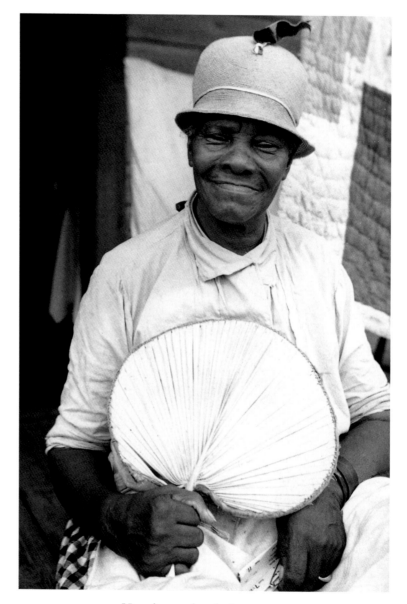

Hat, fan, and quilts/JACKSON

Mother and child/HINDS COUNTY

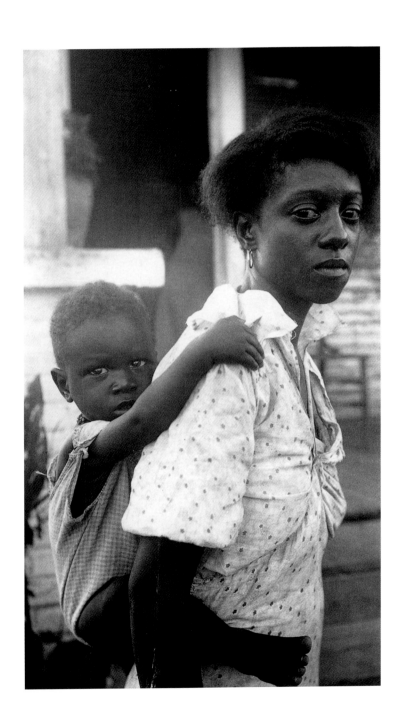

112 *A village pet*/CLAIBORNE COUNTY

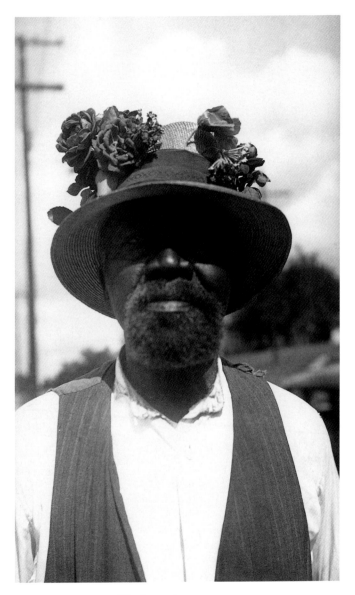

Yard man/CLINTON

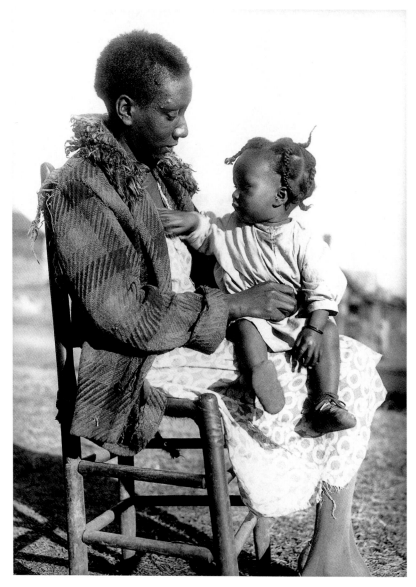

Mother and child/HINDS COUNTY

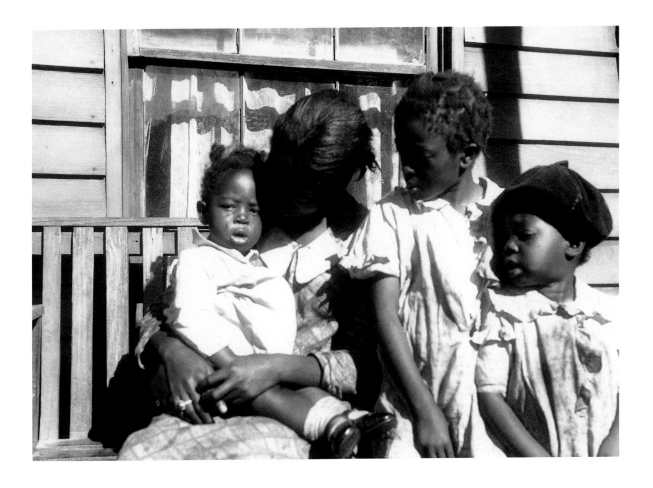

Four sisters/HINDS COUNTY

Home by dark/YALOBUSHA COUNTY

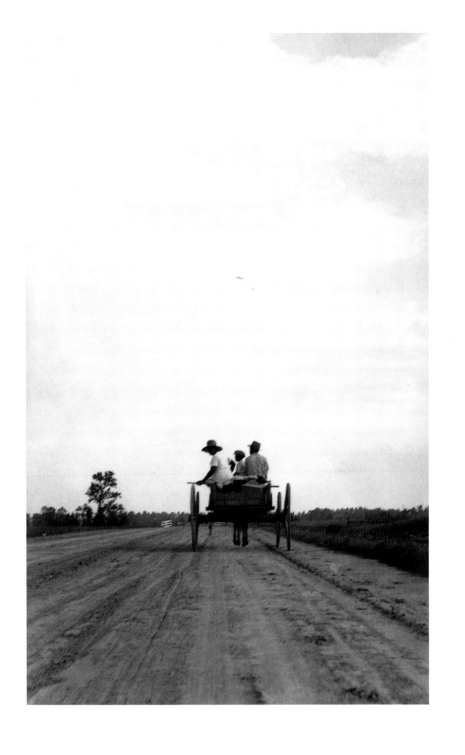

Eudora Welty was born in Jackson, Mississippi, which is still her home. She was educated locally and at Mississippi State College for Women, the University of Wisconsin, and the Columbia University Graduate School of Business. Her short stories have appeared in *The Southern Review*, *The Atlantic Monthly*, *Harper's Bazaar*, *The New Yorker*, and other magazines. She has lectured at a number of colleges, has held the William Allan Neilson professorship at Smith College and the Lucy Donnelly Fellowship at Bryn Mawr College, and was a lecturer at the Conference of American Studies at Cambridge University. She has held a Guggenheim Fellowship and has worked under grants from the Rockefeller Foundation, the Merrill Foundation, and the National Institute of Arts and Letters. She is a member of the American Academy of Arts and Letters.

She has received many honorary degrees (from Columbia University, Smith College, the University of Wisconsin, Harvard University, Millsaps College, the University of Dijon, and others). She also has received the M. Carey Thomas Award from Bryn Mawr, the Brandeis Medal of Achievement, the Hollins Medal, the Edward McDowell Medal, the Howells Medal for her novel *The Ponder Heart*, three first-place prizes of the O. Henry Awards, the Gold Medal for the Novel (National Institute of Arts and Letters), the Pulitzer Prize for her novel *The Optimist's Daughter*, the Frankel Humanities Prize of the National Endowment for the Humanities, the PEN-Malamud Award, the Chevalier de l'Ordre d'Arts et Lettres (France), the National Medal of Literature, the National Medal of Arts, and the Presidential Medal of Freedom. In 1996 she was inducted into France's Legion of Honor.